Nature

HEAVEN'S BREATH

A NATURAL SOURCE OF HEALING

UNPLUGGED

This EXPERIENCE belongs to:

©2015 Art-Unplugged

3101 Clairmont Road · Suite C · Atlanta, GA 30329

This book is not intended to as a substitute for the advice of a mental-health-care provider. The publisher encourages taking personal responsibility for your own mental, physical, and spiritual well-being.

Correspondence concerning this book may be directed to the publisher, at the address above.

Design by Dana Wedman. Illustrations by Lisa Wallace.

ISBN: 1940899001 (Nature)

Printed in the United States of America

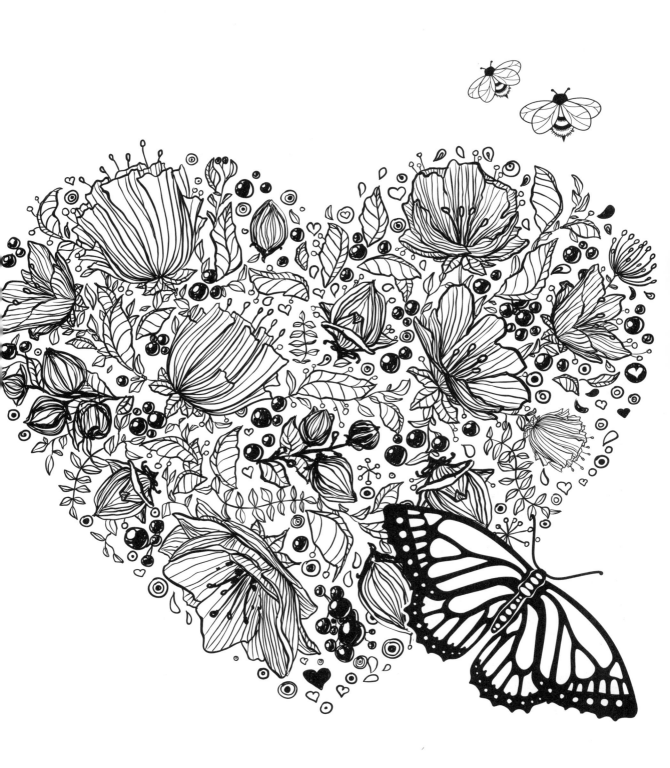

As you color these pages, do your troubles and frustrations melt away? If or when they return, do they seem less troubling and more manageable? Can you get a different perspective on them when you take a break by coloring?

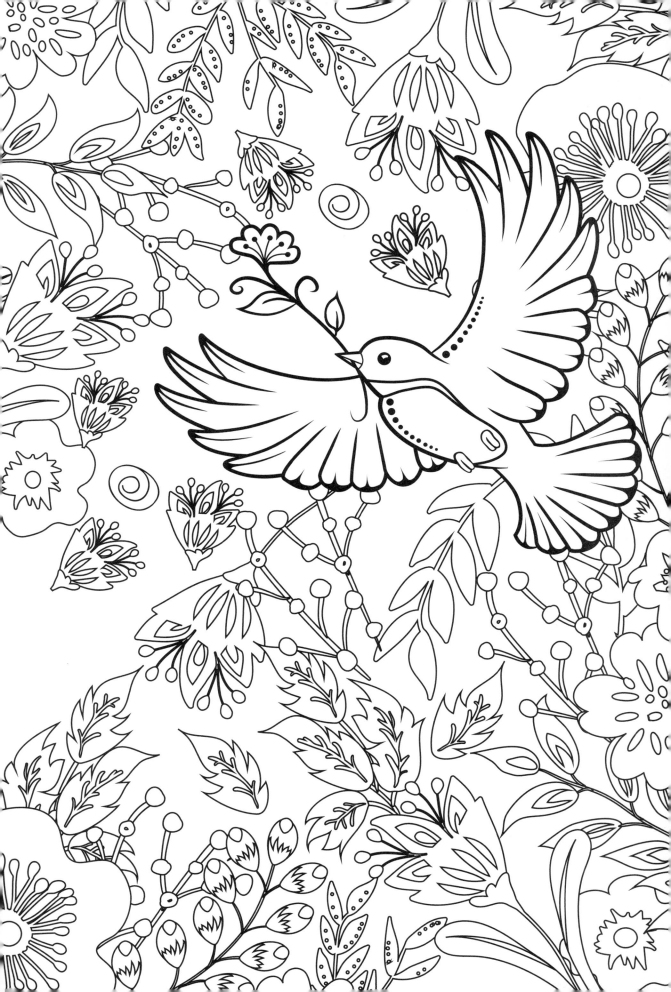

How does this picture make you feel about your life? Are you connected in any way to the image on it?

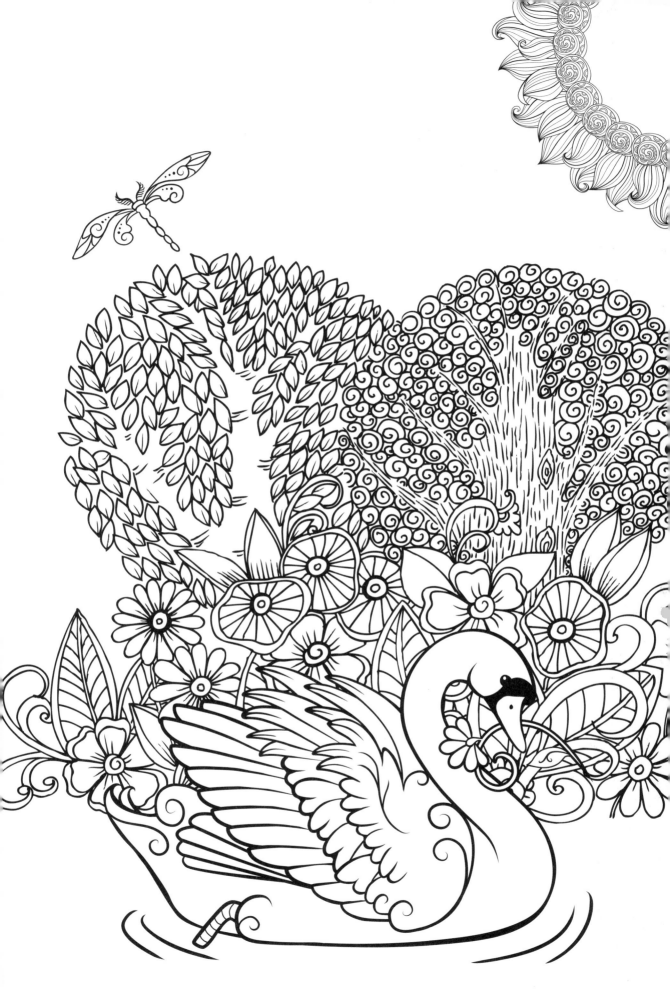

Do you feel more at peace around water, or mountains? Why do you think this is?

What are some names you could give this picture?

What about nature helps you relax?
What about nature energizes you?

Does coloring calm you and comfort you? Describe other practices that make you feel calm.

What does this picture make you wish for? Have you ever wished for that before? What do you believe helps wishes come true?

If you could be any kind of flower, what would it be and why?

Do you find yourself coloring more when you are happy, or stressed? Bored, or nervous? How does coloring help you? How does coloring distract you? Do you consider it a good way to channel your energy?

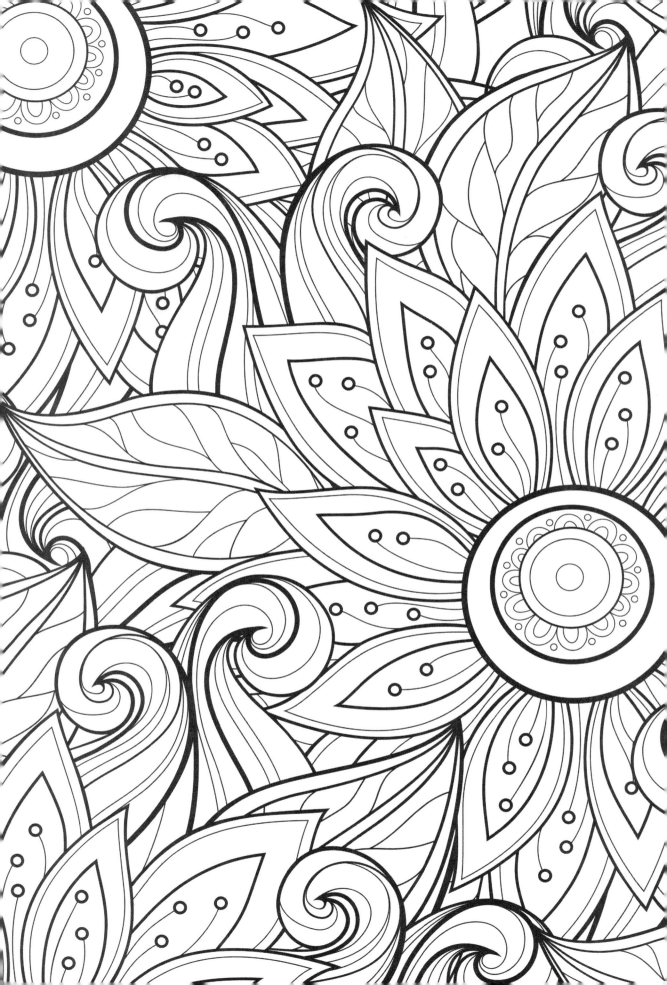

How are you like the perennial flowers that keep coming back year after year in the spring?

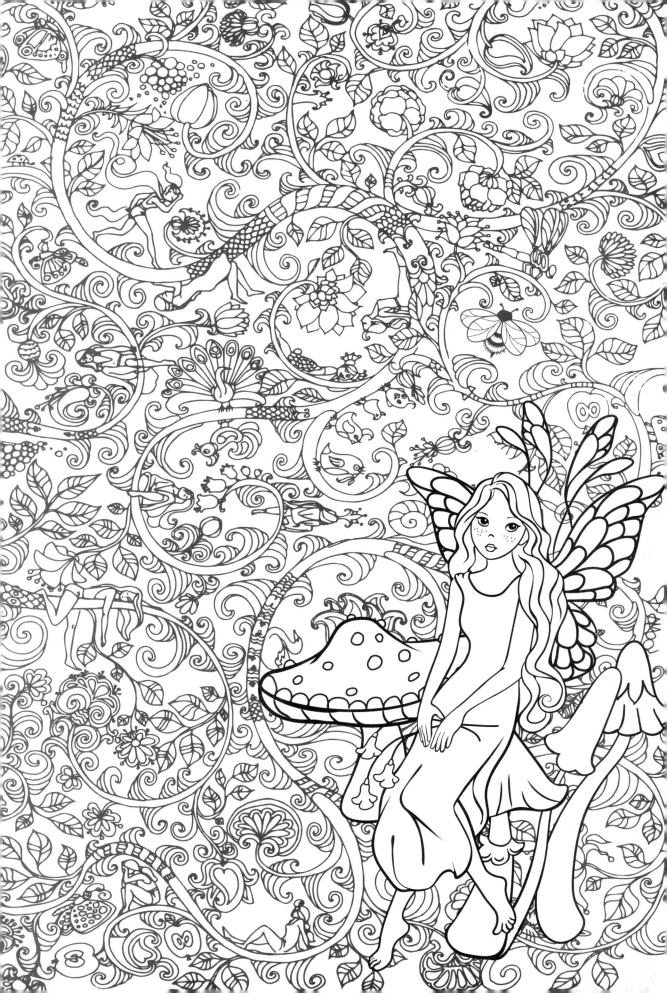

What do you have in common with this picture? Is it happy or serious? Whimsical or realistic?

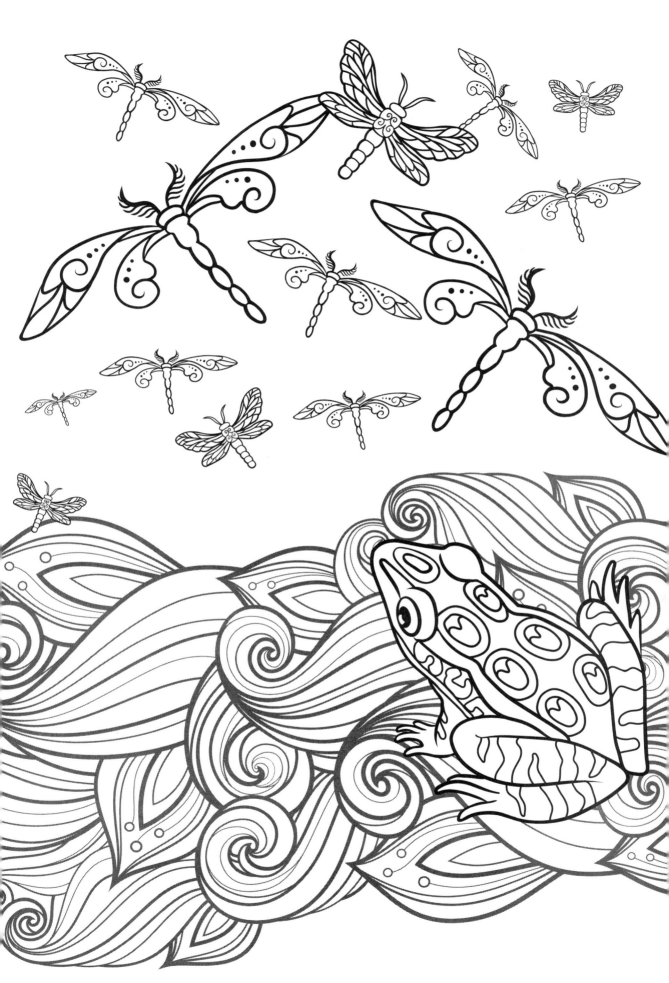

Did you ever look up at the stars and make a wish? What would you wish for today?

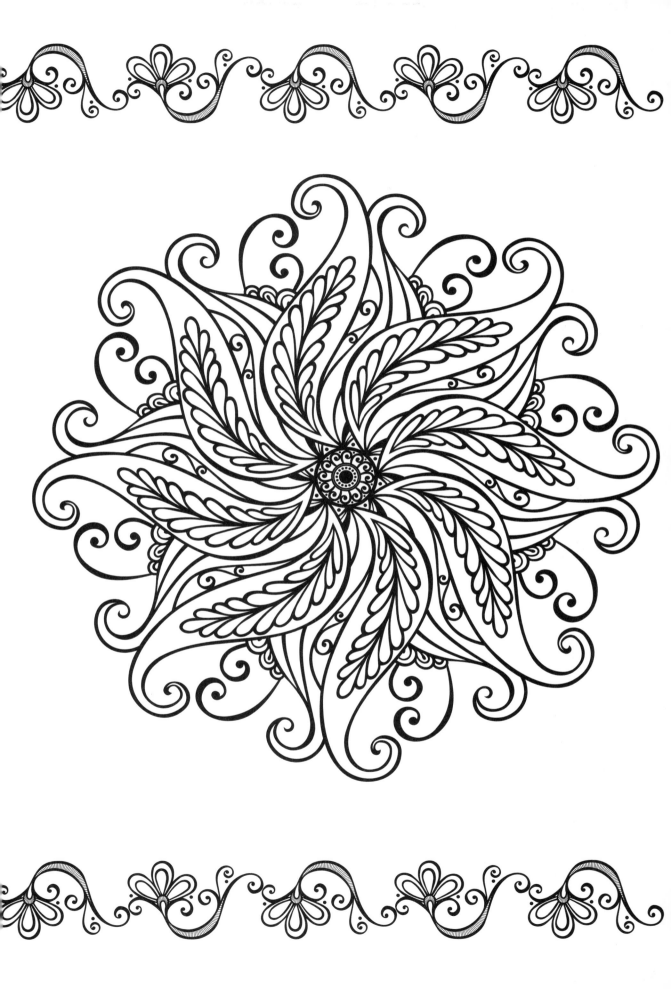

Do you feel afraid or anxious in storms, or do they make you feel more alive? Write about the last storm you were in and how it made you feel.

How can you bring more of the outside world inside your home? What are some specific ways to bring more light and natural features inside your home?

What about this picture makes you grateful? What are you grateful for?

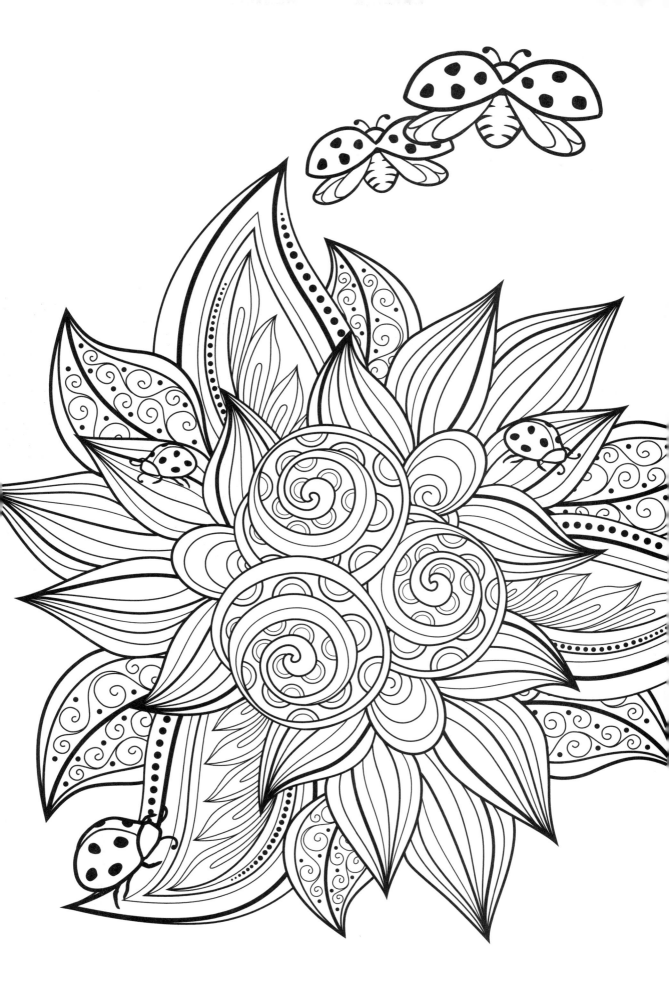

If friends and family were like flowers in your life, what kind of a garden would you have? Would it be big or small? Colorful? Healthy? Well tended by you?

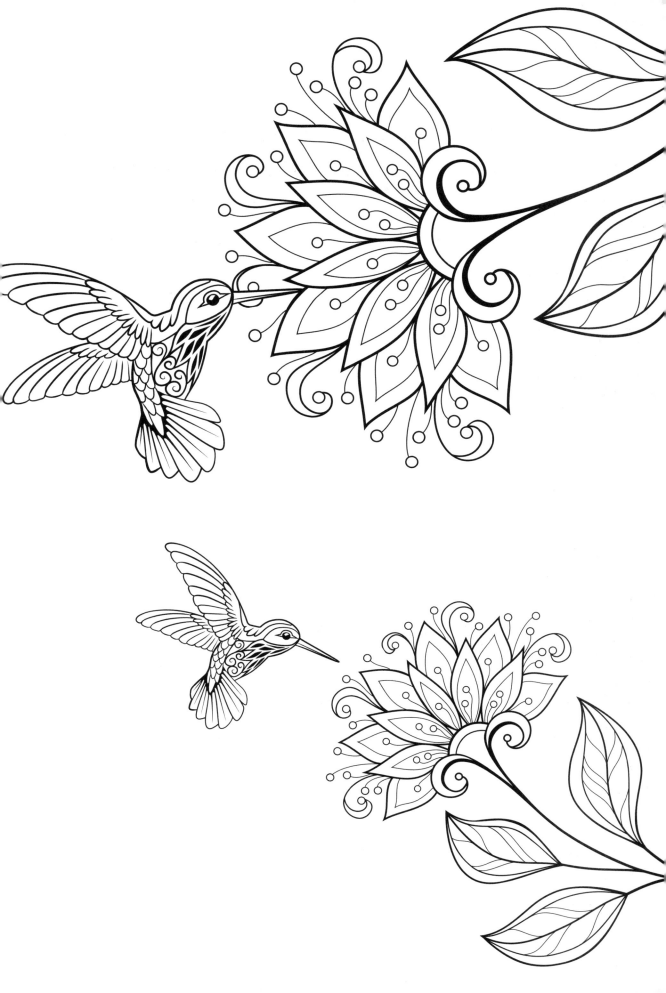

As you color, tap into your feeling of purpose. What else gives you a sense of purpose in life?

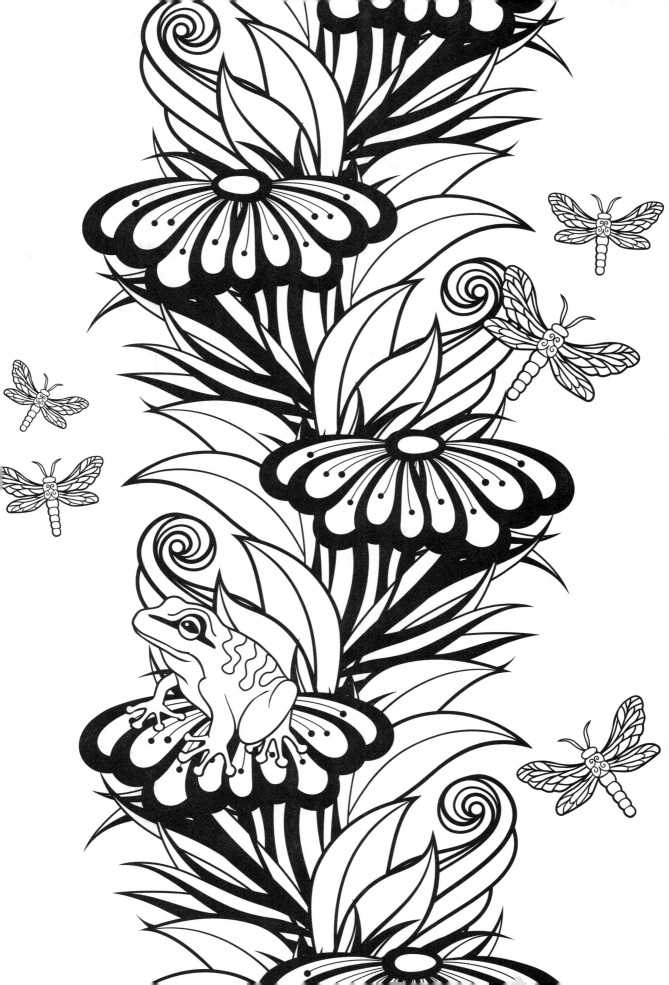

As you color, think about your desire for immediate gratification. What are the pros and cons of immediate gratification in your life? Try not to judge your thoughts! Just be aware of them.

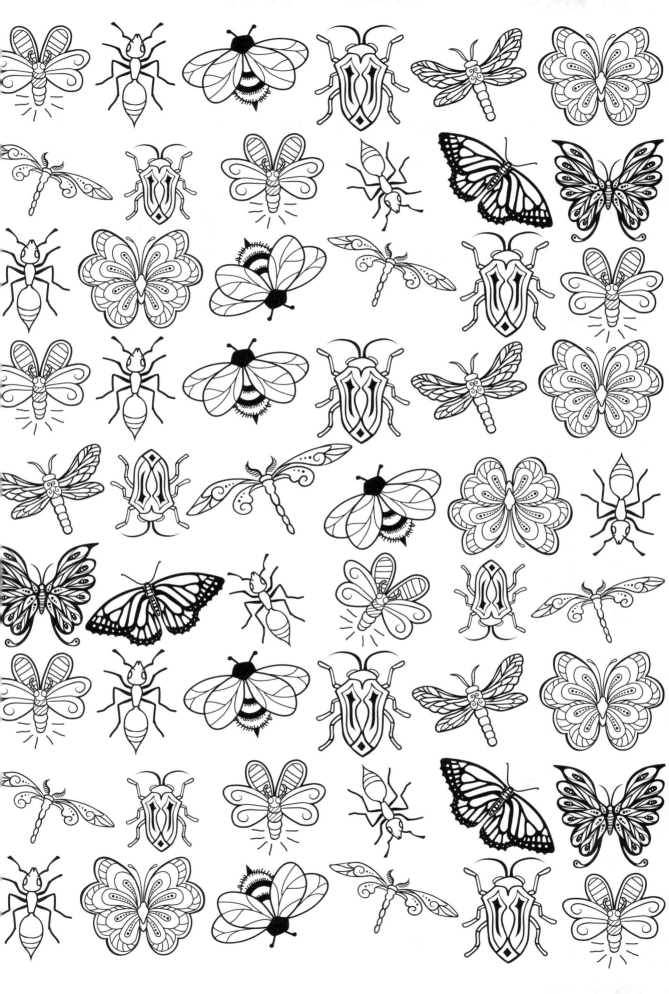

What kinds of sounds bring you joy in nature? The sound of water, the rustle of wind? Do these sounds remind you of happier times? Do they stir up bittersweet memories?

If you could create any backyard to live in, what would it be like? Why are those features important to you? How would this kind of environment make you feel more alive?

How does this picture inspire you to be your best? How do you define the word best? Can your best be different from someone else's best? Why does this matter?

When you reflect on this picture, think about what you hope for in life. What are your hopes for today?

What about nature connects you to your faith?

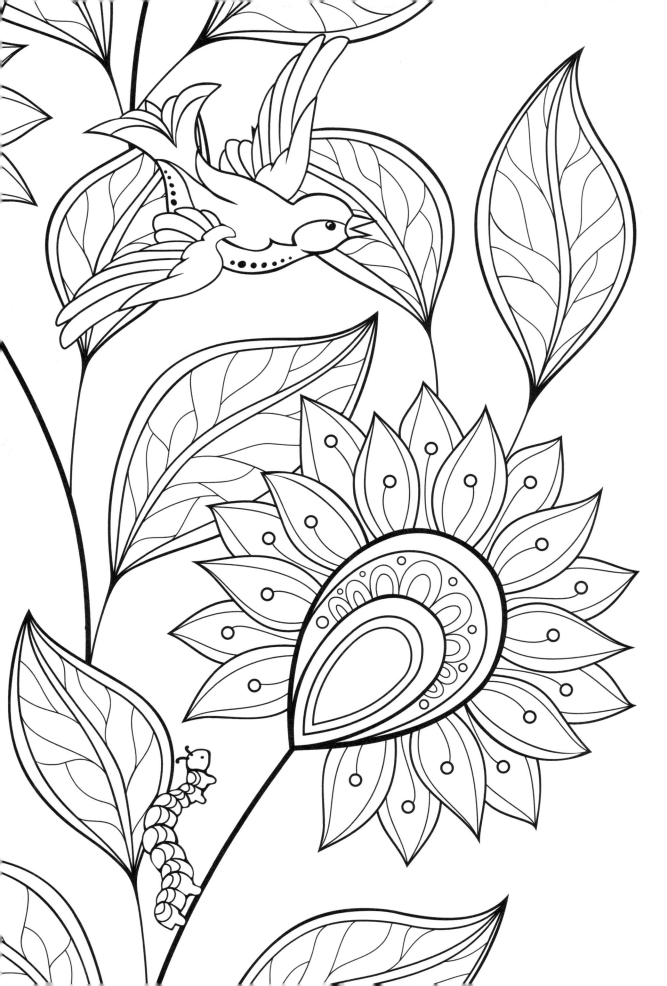

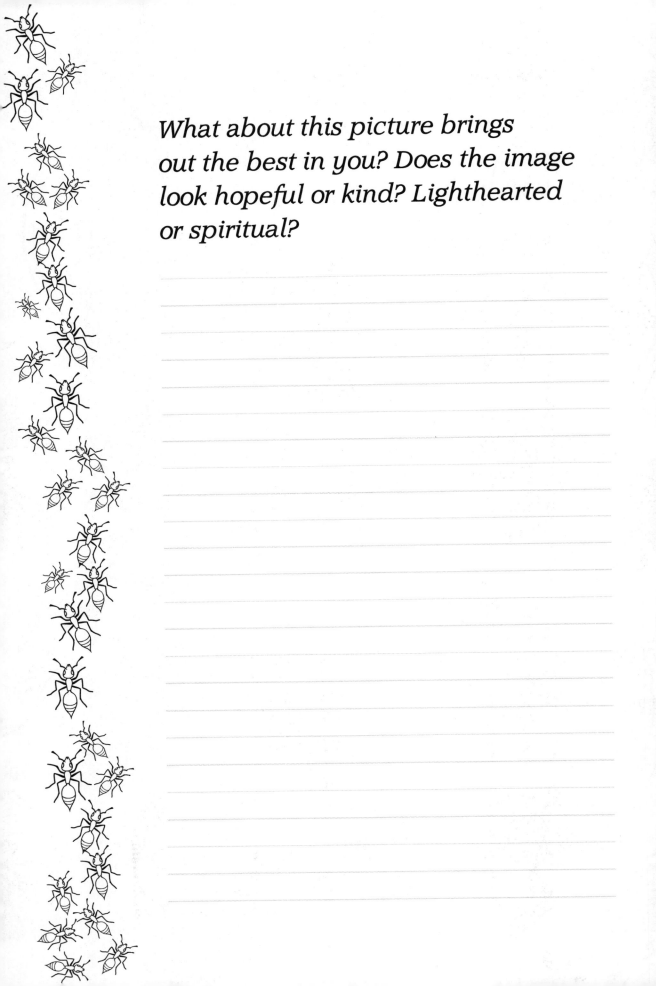

What about this picture brings out the best in you? Does the image look hopeful or kind? Lighthearted or spiritual?

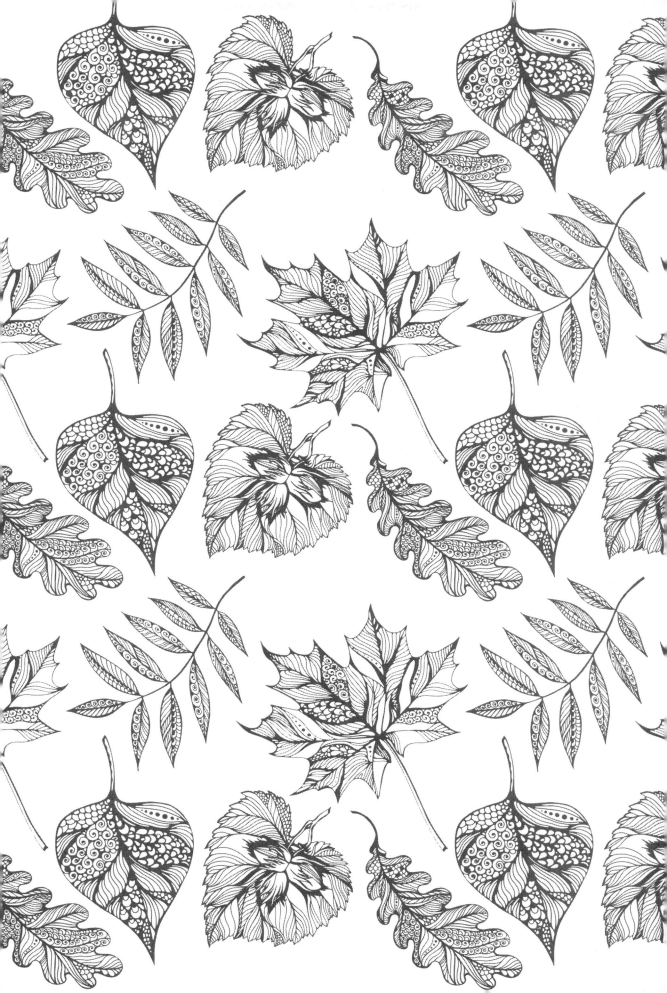

What is your favorite season of the year? Why?

Have you ever climbed up a mountain
or big hill? How is this like your life?
How do you feel when you think
about getting to the top?

How does coloring these small spaces create a sense of importance in your life?

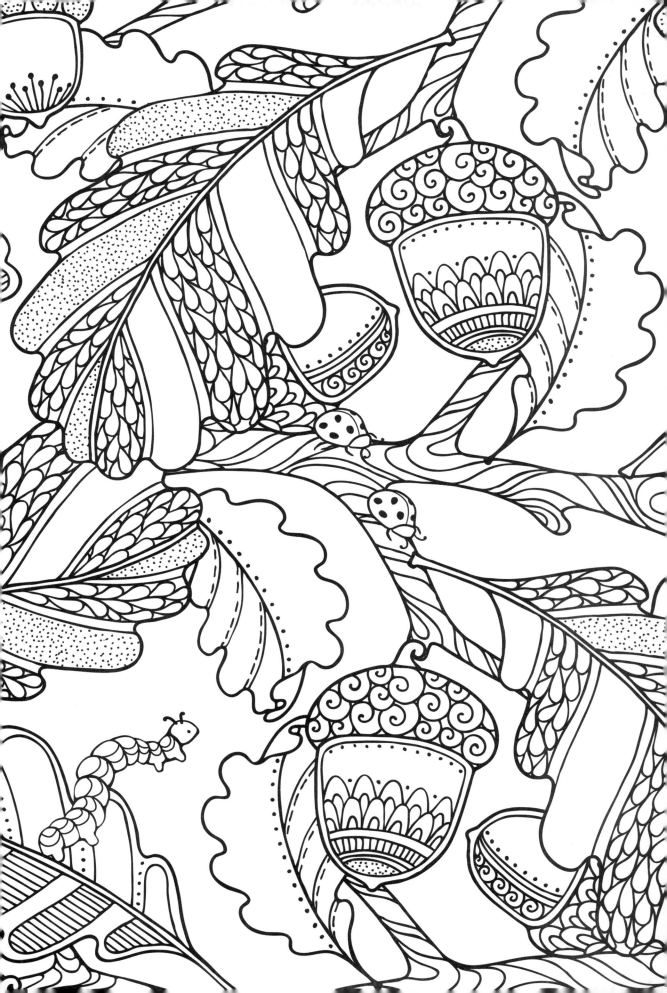

What are your favorite scents in nature? Sea water? Freshly cut grass? Fields of flowers? Why? Do they stir up any important memories?

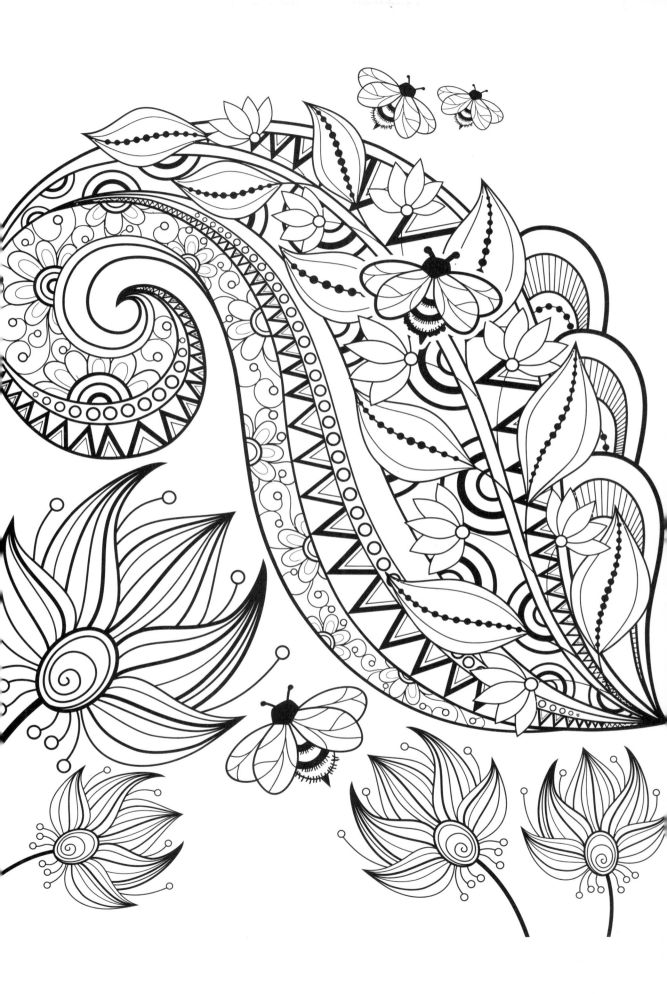

Do you have a favorite kind of cloud?
How do the clouds affect your mood?

What are your best childhood memories of playing outside? How could you relive those again?

What colors do you gravitate toward in your artwork? How do different colors make you feel? Does the color red stir up different feelings in you than the color blue? Which colors make you feel calmer? Can you surround yourself with more of this color? How and where?